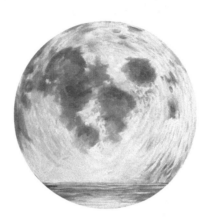

# SEVEN
## WHOLE DAYS

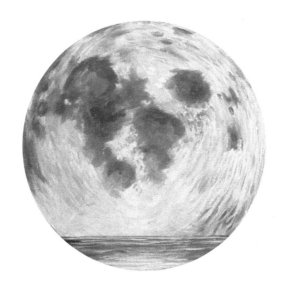

# SEVEN
## WHOLE DAYS

63 LINES OF POETRY AND 63 PAINTINGS INSPIRED
BY THE GENESIS ACCOUNT OF CREATION

POETRY BY **MALCOLM GUITE** ILLUSTRATED BY **FAYE HALL**

**Seven Whole Days**
Copyright ©2017 Faye Hall and Malcolm Guite
All rights reserved
Printed in Canada
ISBN 978-1-927355-97-8 soft cover
ISBN 978-1-927355-14-5 hard cover
ISBN 978-1-927355-98-5 EPUB

Published by:
Castle Quay Books
Burlington, Ontario
Tel: (416) 573-3249
E-mail: info@castlequaybooks.com    www.castlequaybooks.com

Cover design and book interior by Roberta Landreth of DesignbyRoberta.com
Printed at Marquis Printing, Sherbrooke (Québec)

*Seven Whole Days* © Malcolm Guite, Canterbury Press Press, 27 May 2016.  Reproduced by permission of Hymns Ancient & Modern Ltd.
Used by permission. rights@hymnsam.co.uk

Scripture taken from the Holy, Bible, King James Version which is in the public domain.

**Library and Archives Canada Cataloguing in Publication**

Guite, Malcolm, author
      Seven whole days : 63 lines of poetry, 63 paintings, inspired by the Genesis
account of Creation / poetry by Malcolm Guite ; illustrated by Faye Hall.

ISBN 978-1-927355-14-5 (hardcover).--ISBN 978-1-927355-97-8 (softcover)

      I. Hall, Faye, 1957-, illustrator  II. Title.  III. Title: Sixty-three lines of
poetry, sixty-three paintings, inspired by the Genesis account of Creation.

PR6107.U48S48 2017           823'.92           C2017-906404-5

# AUTHOR ACKNOWLEDGEMENTS

I am very grateful to Faye Hall for responding to my suggestion that she might interpret my poetry sequence "Seven Whole Days" through her art. She has created a beautiful new work in response to mine that not only interprets and illustrates what I have written but stands up as a sequence in its own right. I hope this collaboration will invite readers and gazers to rekindle their delight in God's good creation and to glimpse a little of how His glory shines through it all. I am grateful to my publisher Canterbury Press for granting us permission to reproduce the text of this poem as it first appeared in my book *Parable and Paradox*.

**Malcolm Guite**

Thank you to Malcolm Guite—without whose listening ear to his Creator, this book would not exist. To Steve Bell and Amy Knight, models for some of the paintings, and for Steve's encouragement and mentorship. To my dear husband, Darrell, for his constant and loving support. To Waldy Derksen for his sponsorship, Dave Swiecicki for art photography, and Roberta Landreth for book design.

   Above all, thanks to our Creator:

For the invisible things of him from the creation of the world are clearly seen, being understood by the things that are made, even his eternal power and Godhead; so that they are without excuse. (Romans 1:20)

**Faye Hall**

# FOREWORD

As a songwriter, having worked with the poetry of Malcolm Guite, I know something of having my own artistry deepened by another's. It's a wonder, really, to find yourself delving into regions you'd never have come to on your own, and yet the work is still yours. Alternatively, as someone whose artistry has inspired paintings by Faye Hall, I also know something of what it's like to have one's work taken up by another and transmuted into an entirely different form. I've literally "seen" my songs as paintings: colour and shape and motion and contrast and texture and ... well ... mystery. It is enough to leave one still and silent in awe.

Imagination, mutuality and exchange between artists can be a delicate and powerful phenomenon, and I suspect the reason it moves us so is that it gives us a glimpse into the inner workings of the Holy Trinity, whose dynamic relationality has resulted in a riot of far-flung galaxies all the way down to anthills, birdsong and salmon runs.

What you have in your hands is a human mirror of a divine activity—a fruitful exchange—and I am more than pleased to commend it to you.

**Steve Bell**
*Singer / Songwriter / Storyteller*

"Seven whole days, not one in seven, I will praise thee."

*- George Herbert*

# DAY 1

In the beginning God created the heaven and the earth. And the earth was
without form, and void; and darkness was upon the face of the deep. And
the Spirit of God moved upon the face of the waters. And God said, Let
there be light: and there was light. And God saw the light, that it was good:
and God divided the light from the darkness. And God called the light Day,
and the darkness he called Night. And the evening and
the morning were the first day.

**GENESIS 1:1–5**

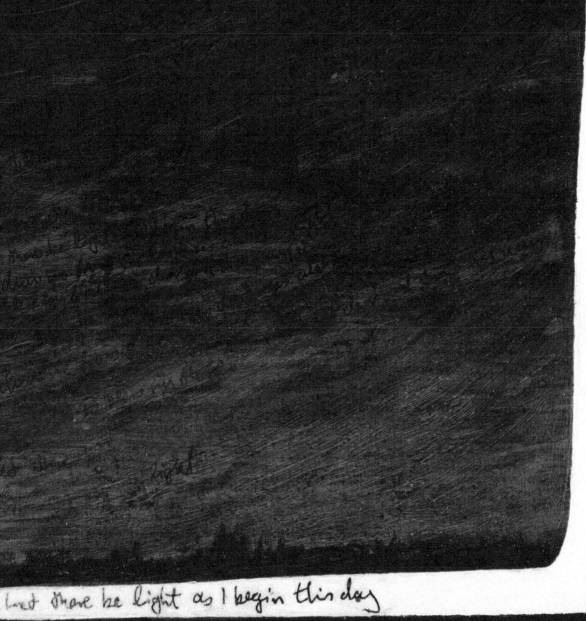

Let there be light as I begin this day

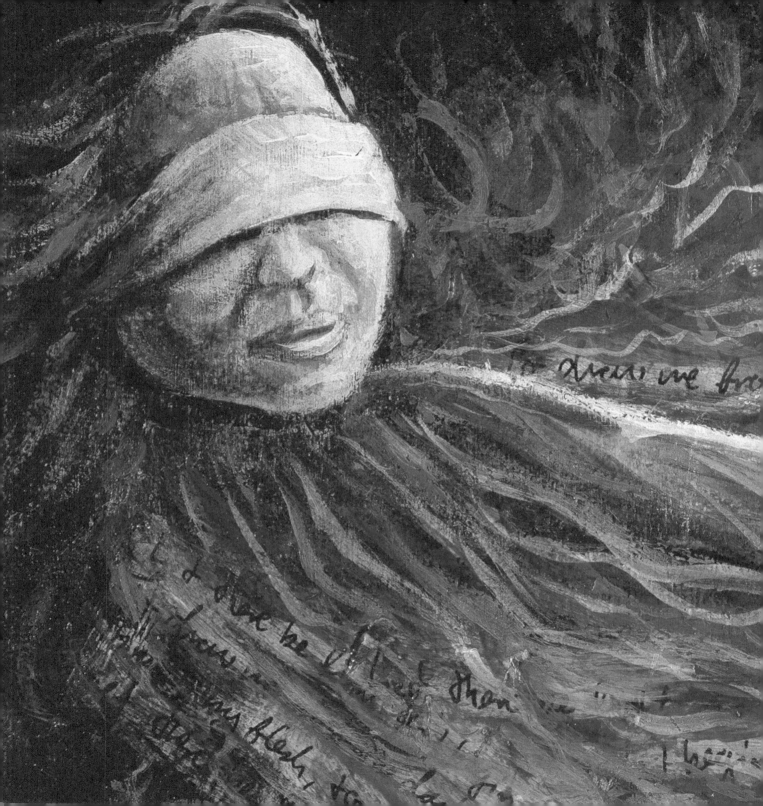

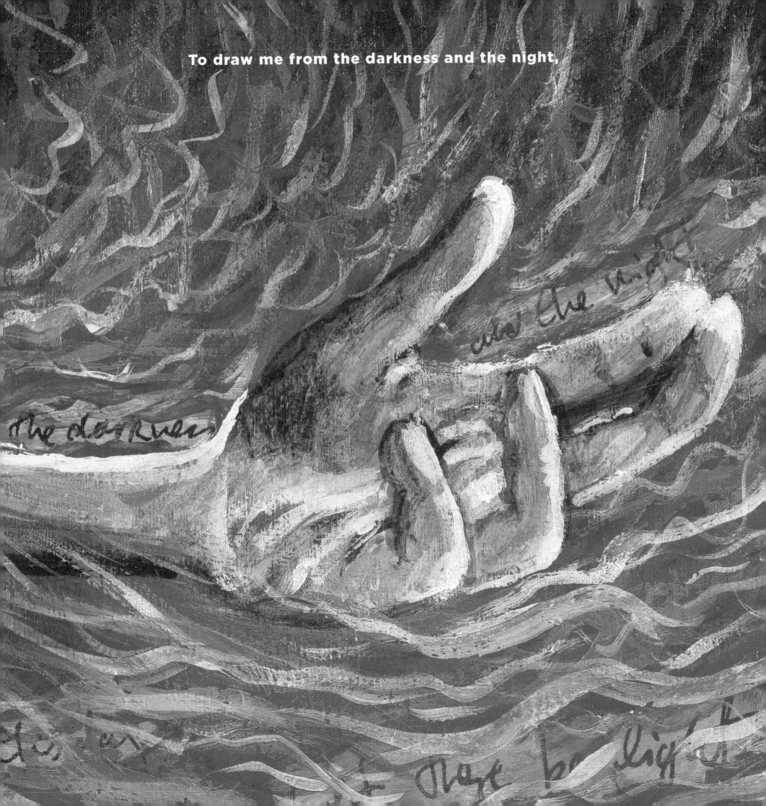

To draw me from the darkness and the night,

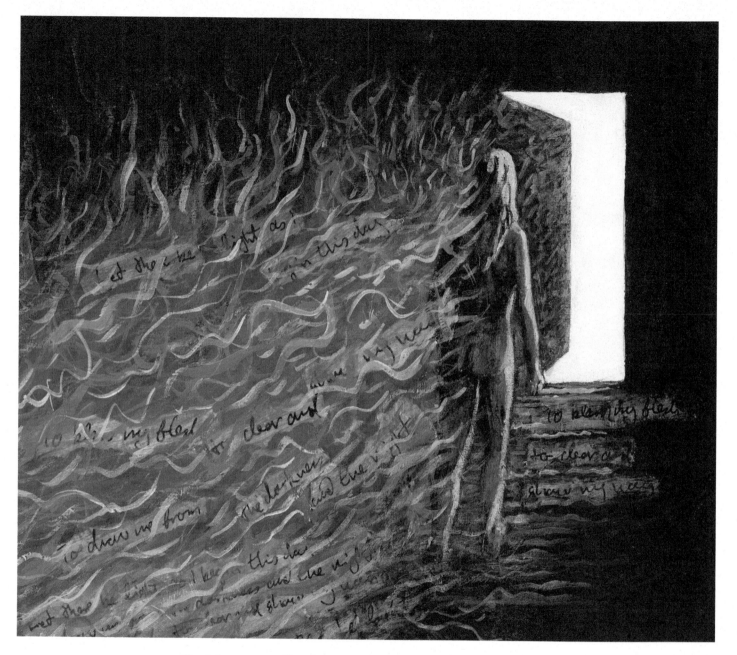

To bless my flesh, to clear and show my way.
Let there be light.

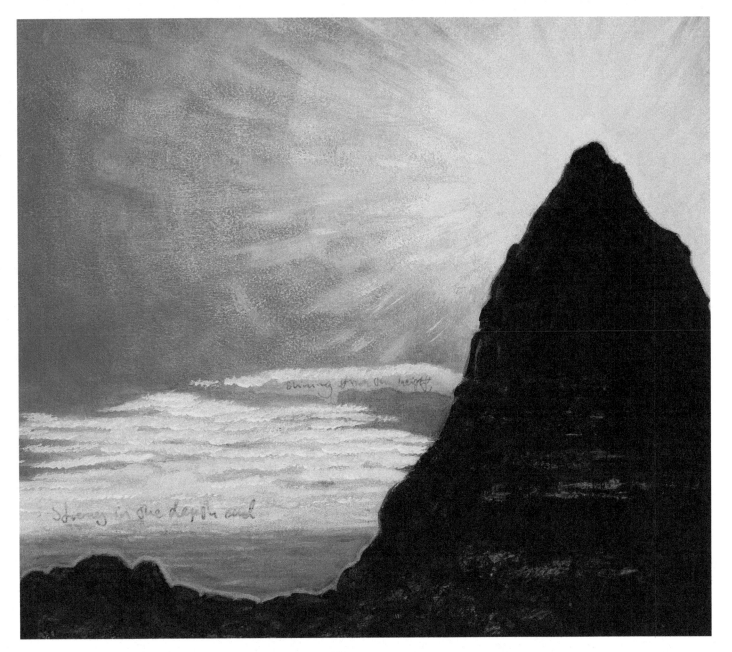

Strong in the depth and shining from the height,

Evening and morning's interplay,

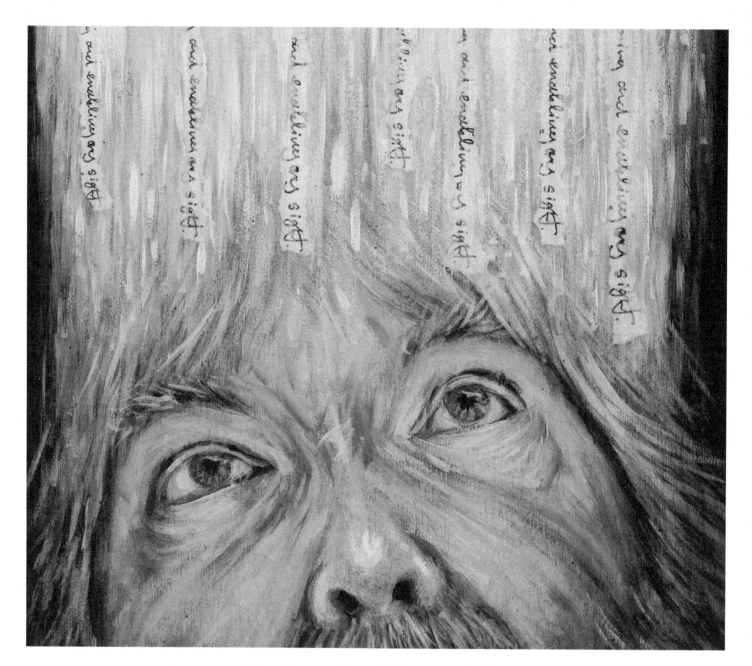

Blessing and enabling my sight.

Lighten my soul and teach me how to pray,

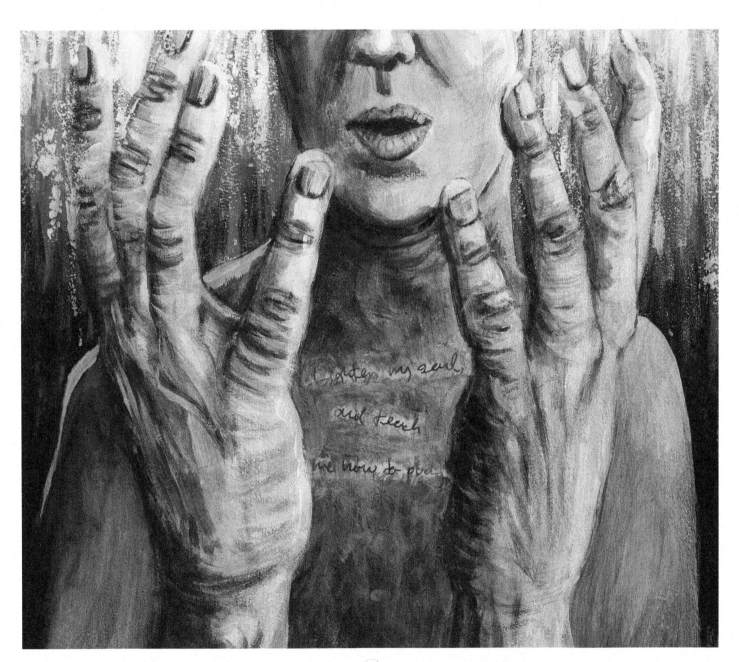

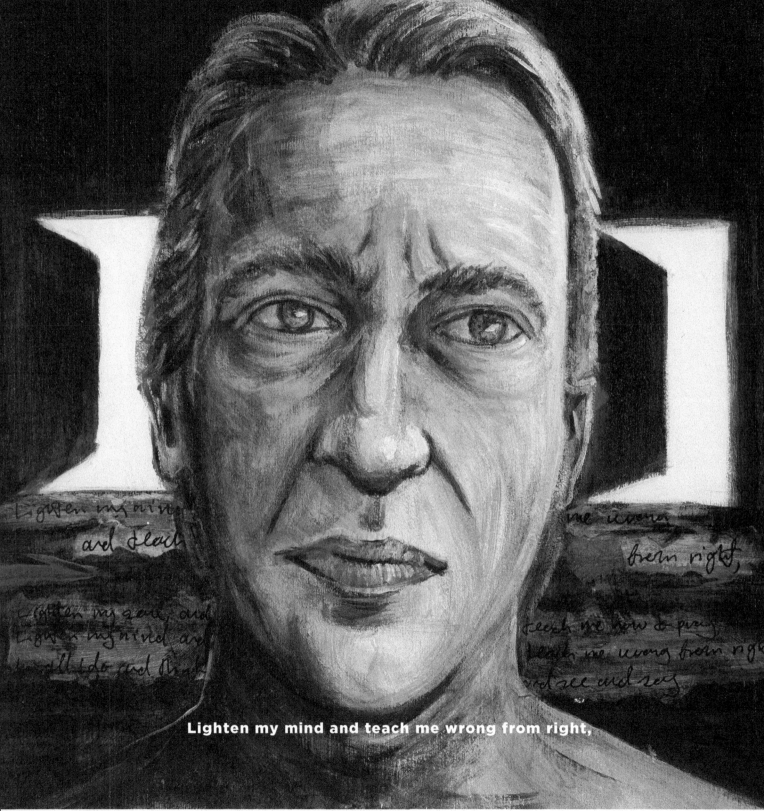

Lighten my mind and teach me wrong from right,

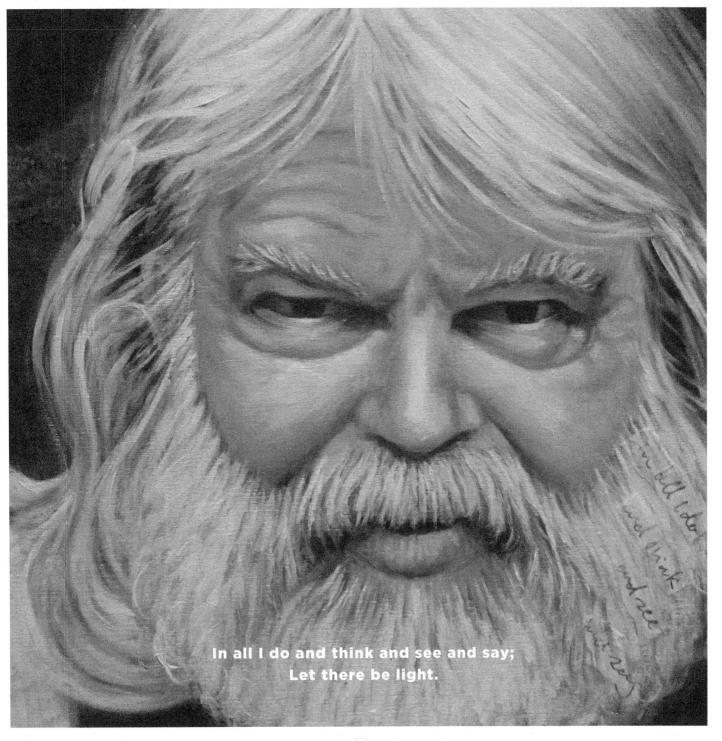

In all I do and think and see and say;
Let there be light.

# DAY 2

And God said, Let there be a firmament in the midst of the waters, and let it divide the waters from the waters. And God made the firmament, and divided the waters which were under the firmament from the waters which were above the firmament: and it was so. And God called the firmament Heaven. And the evening and the morning were the second day.

**GENESIS 1:6-8**

The firmament, the vast curve of the sky

# The breath and weave of every element

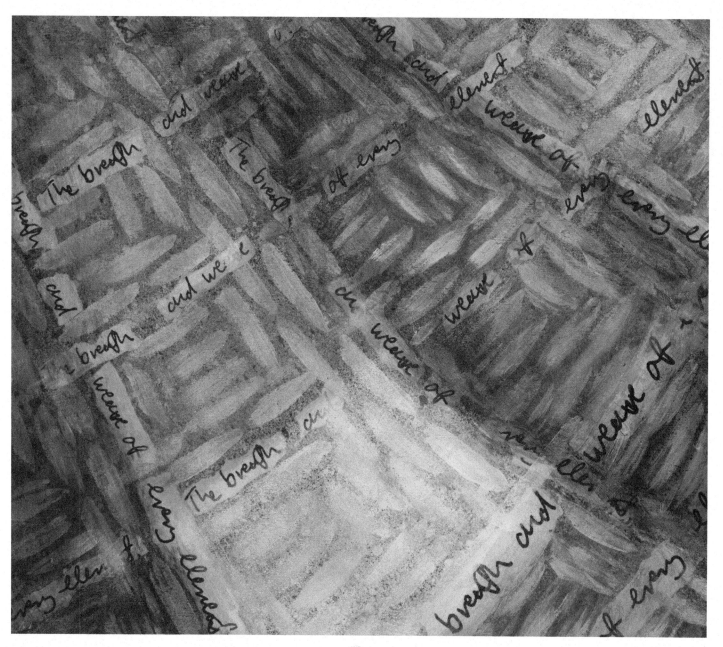

Unending blue, wherein we long to fly; the firmament.

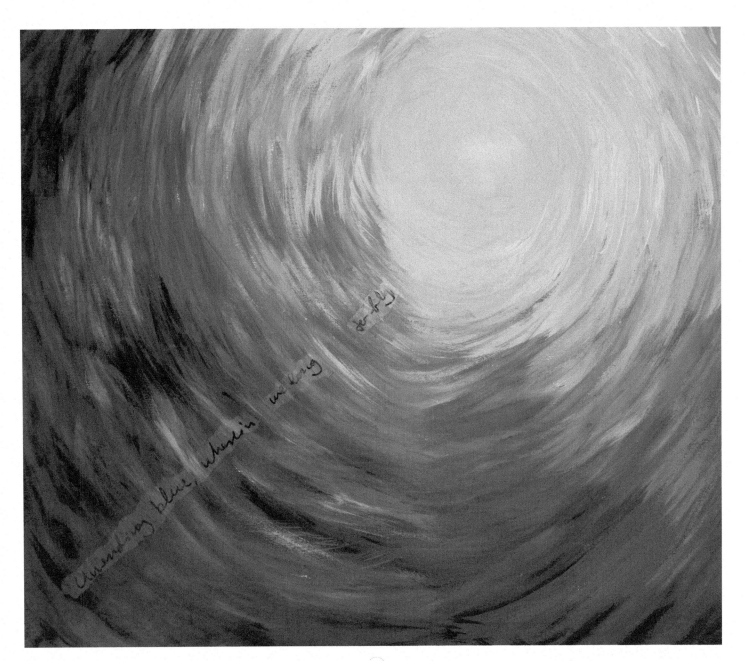

Your love has pitched the heavens like a tent

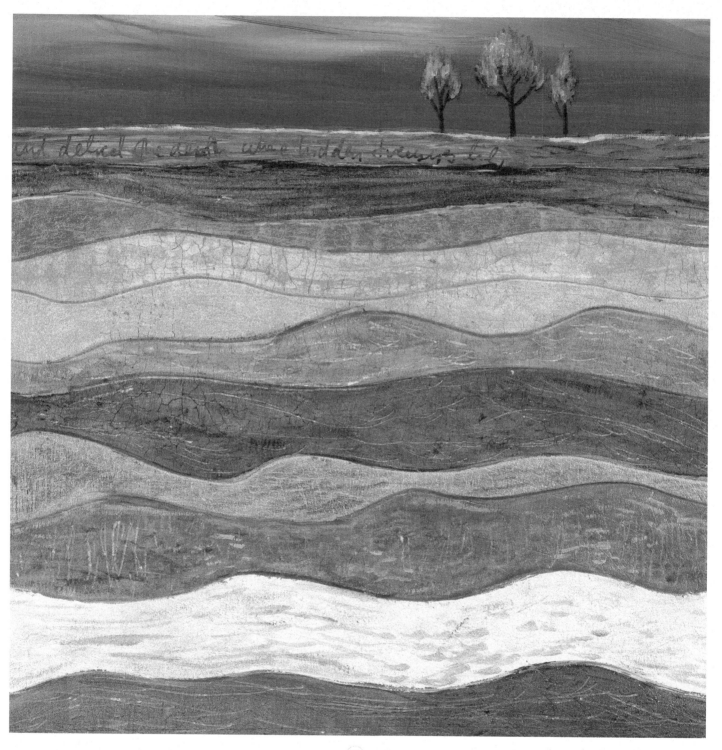

And delved the depth where hidden treasures lie,

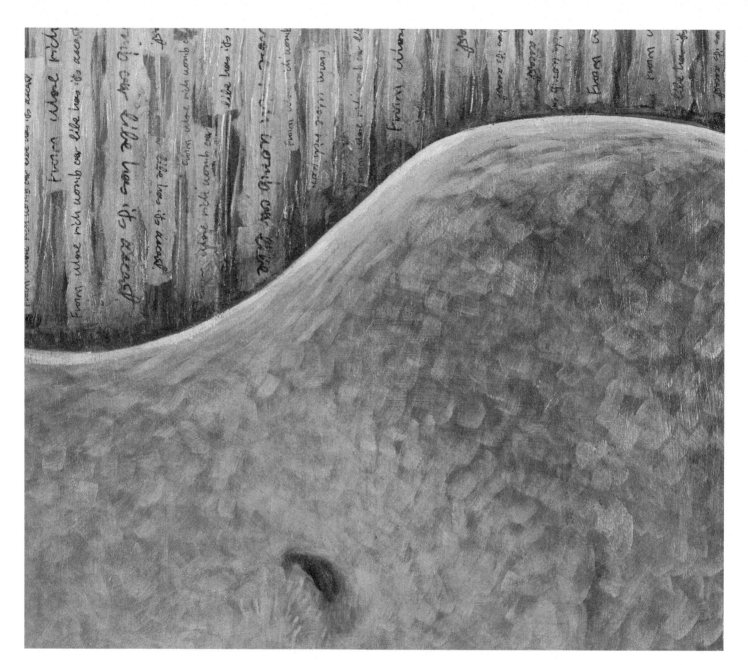

From whose rich womb our life has its ascent.

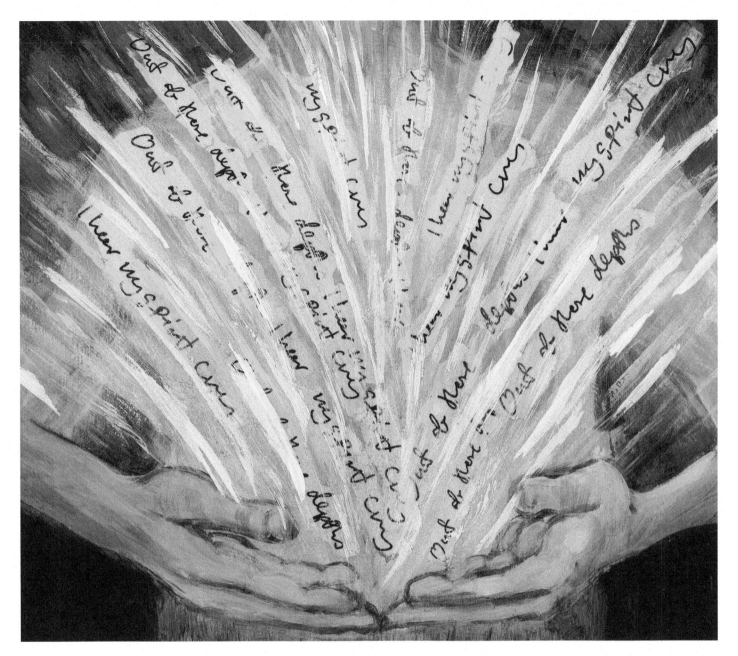

Out of those depths I hear my spirit cry

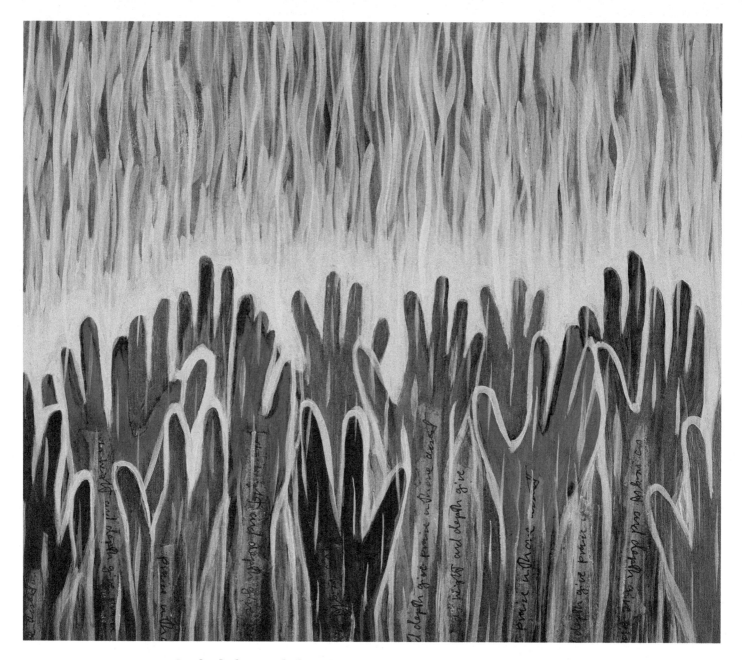

As height and depth give praise with one assent

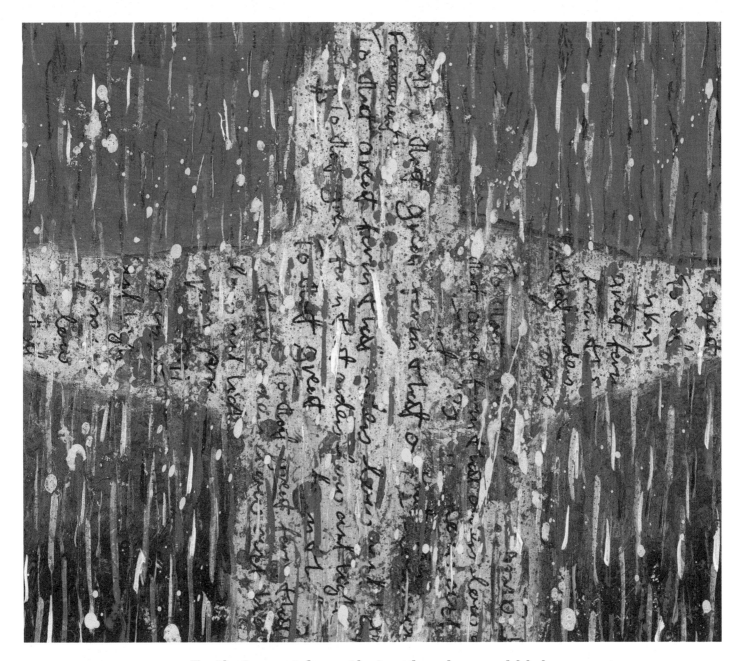

To that great form that orders low and high;
The firmament.

# DAY 3

And God said, Let the waters under the heaven be gathered together unto one place, and let the dry land appear: and it was so. And God called the dry land Earth; and the gathering together of the waters called he Seas: and God saw that it was good. And God said, Let the earth bring forth grass, the herb yielding seed, and the fruit tree yielding fruit after his kind, whose seed is in itself, upon the earth: and it was so. And the earth brought forth grass, and herb yielding seed after his kind, and the tree yielding fruit, whose seed was in itself, after his kind: and God saw that it was good. And the evening and the morning were the third day.

**GENESIS 1:9-13**

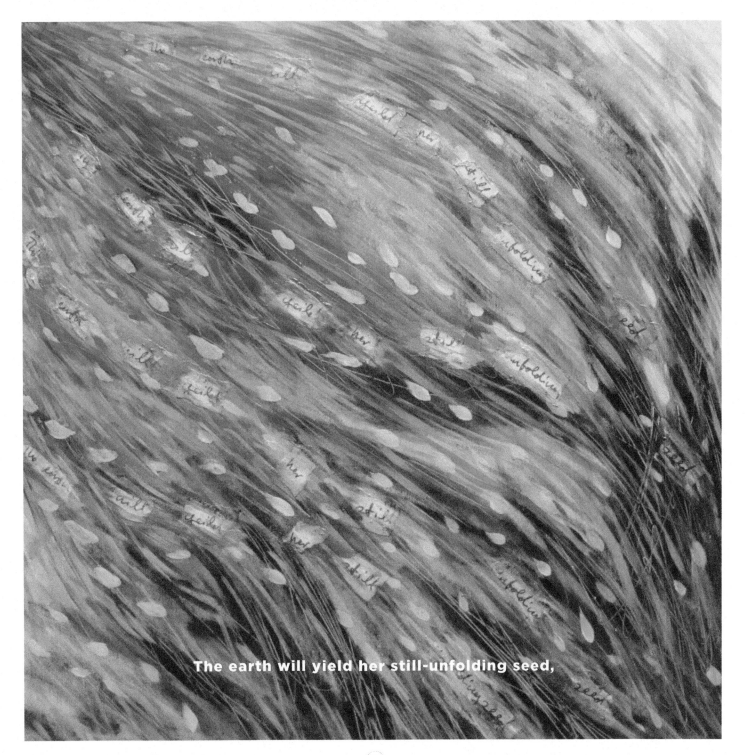

The earth will yield her still-unfolding seed,

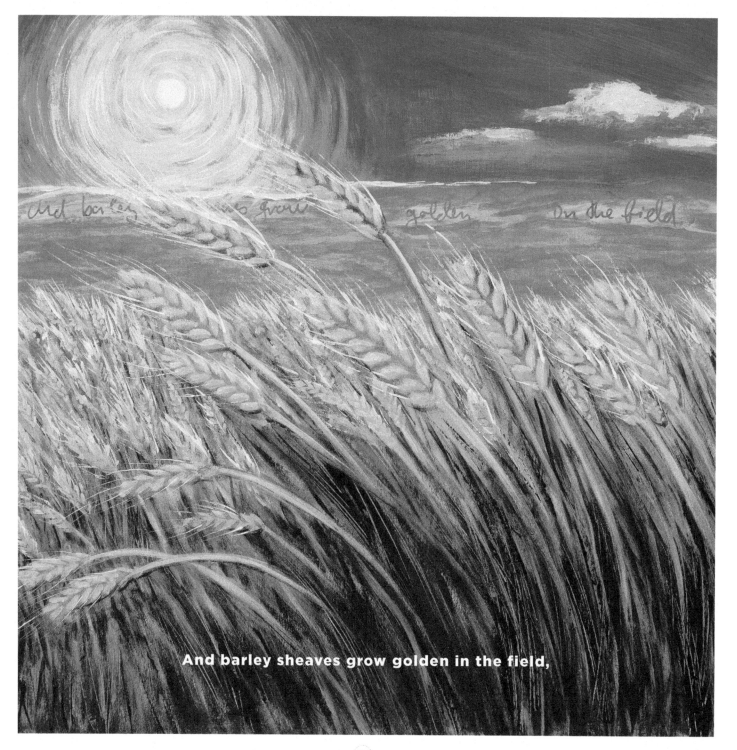

And barley sheaves grow golden in the field,

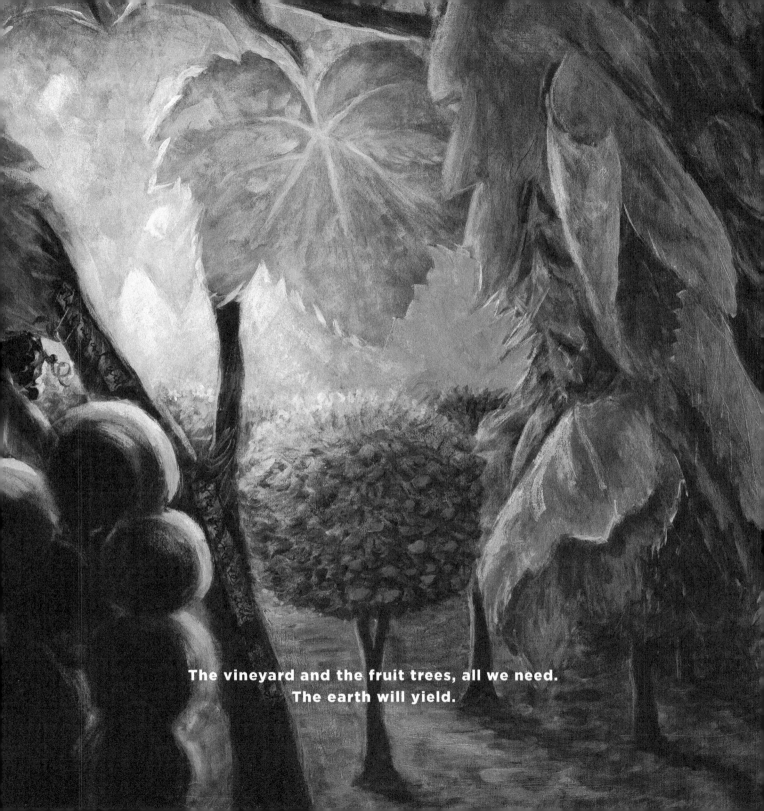

The vineyard and the fruit trees, all we need.
The earth will yield.

A soft wind sends the summer through the weald;

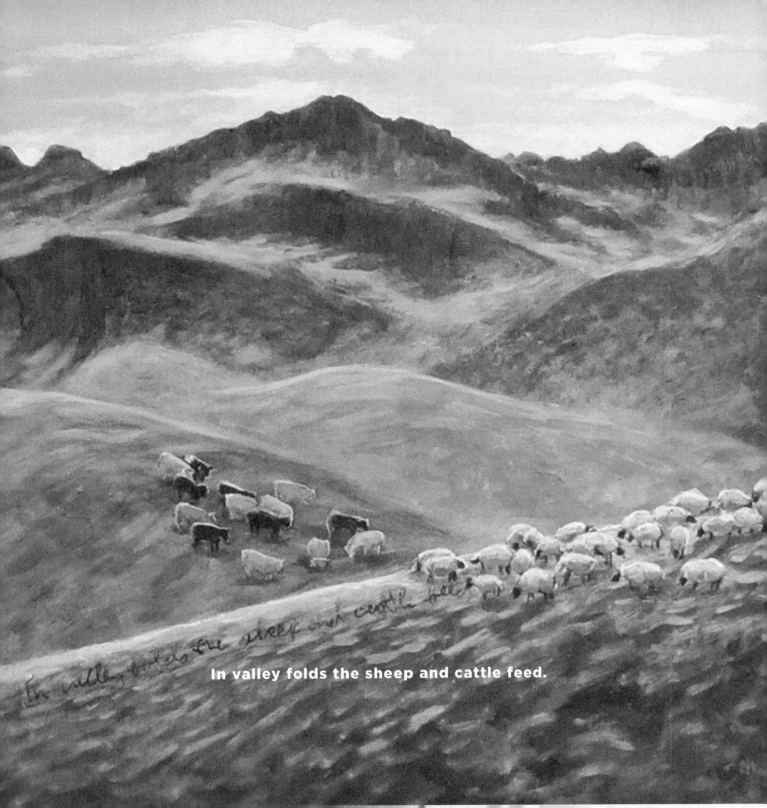

In valley folds the sheep and cattle feed.

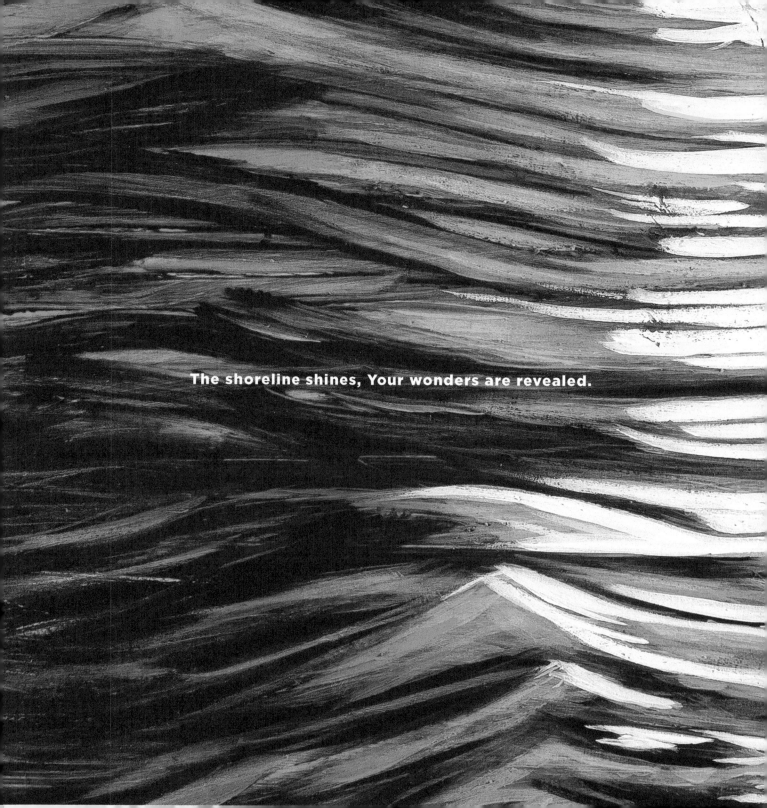

The shoreline shines, Your wonders are revealed.

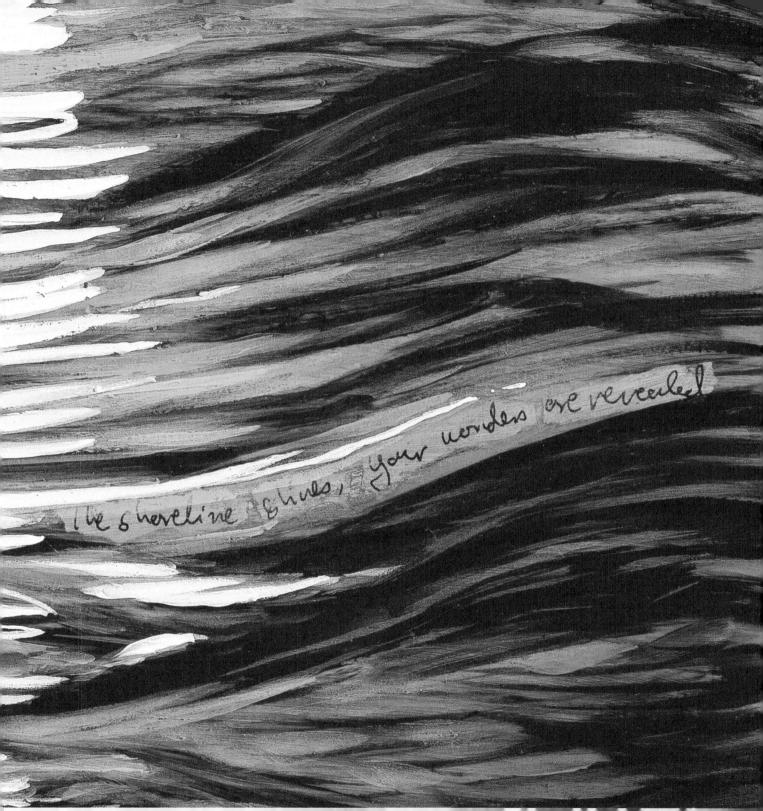

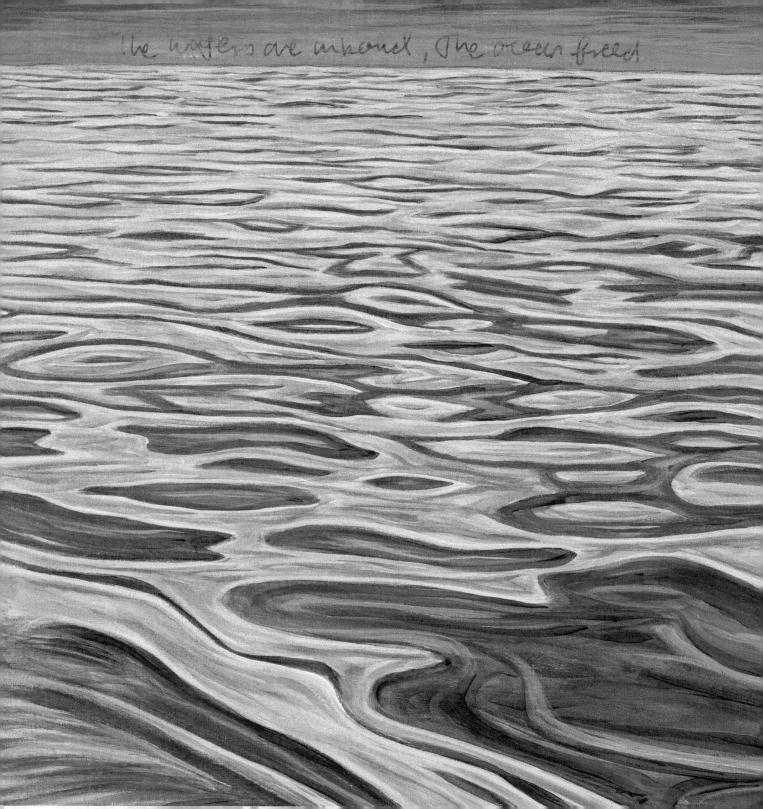

the waters are unbound, the ocean freed

The waters are unbound, the ocean freed

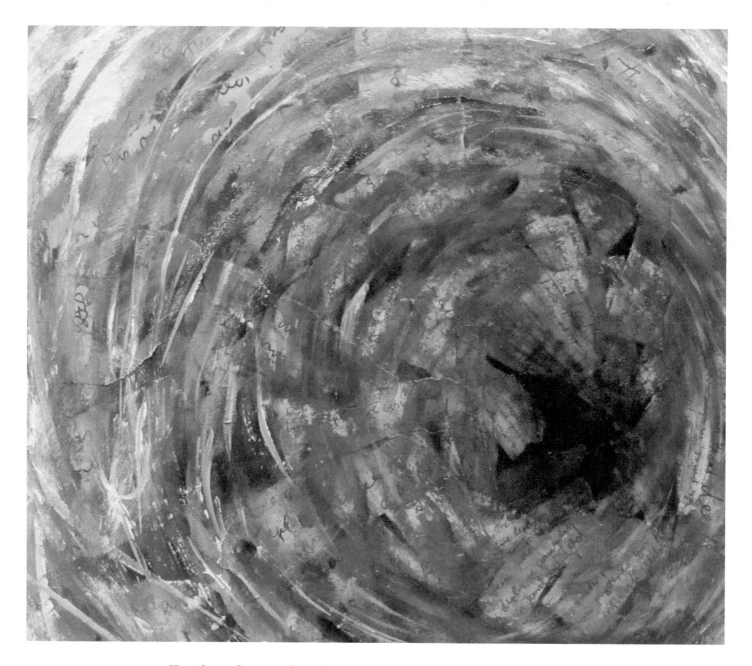

**To thunder praise, in whose depths are concealed**

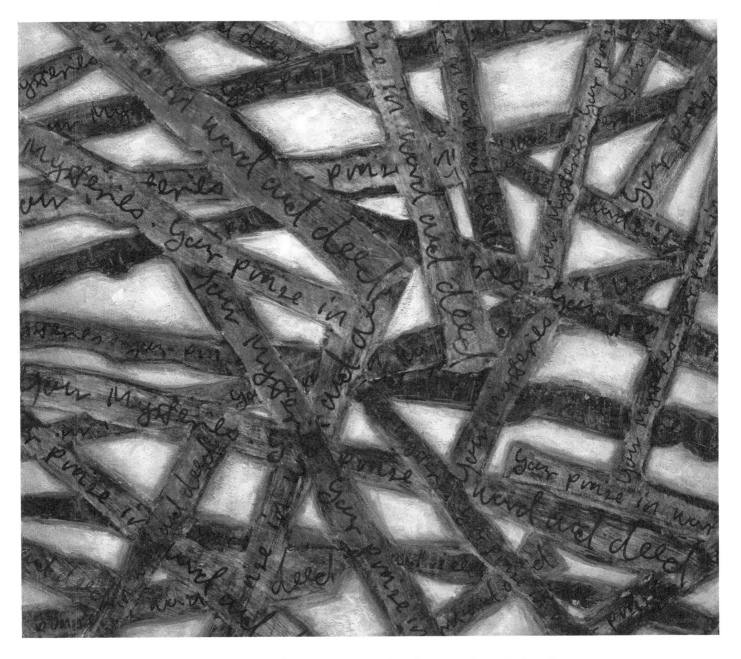

Your mysteries. Your praise in word and deed.
The earth will yield.

# DAY 4

And God said, Let there be lights in the firmament of the heaven to divide the day from the night; and let them be for signs, and for seasons, and for days, and years: And let them be for lights in the firmament of the heaven to give light upon the earth: and it was so. And God made two great lights; the greater light to rule the day, and the lesser light to rule the night: he made the stars also.

**GENESIS 1:14–16**

Lights in the night, the lucid moon and sun,

The lesser and the greater share Your light

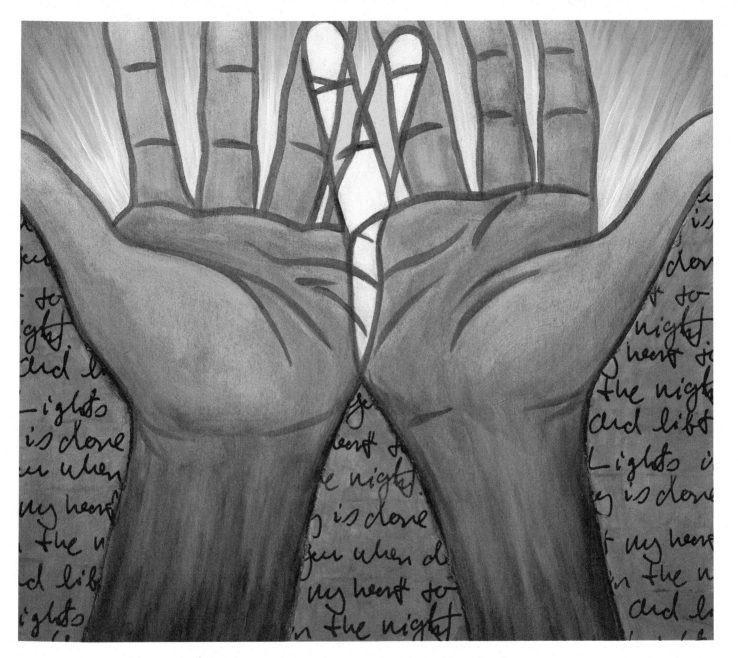

And lift my heart to You when day is done.
Lights in the night.

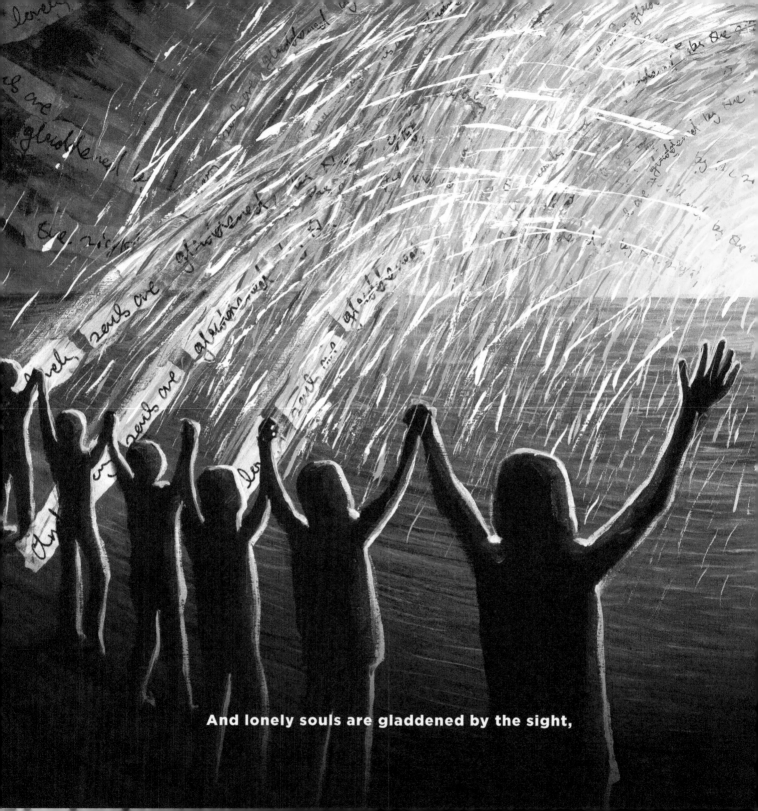

And lonely souls are gladdened by the sight,

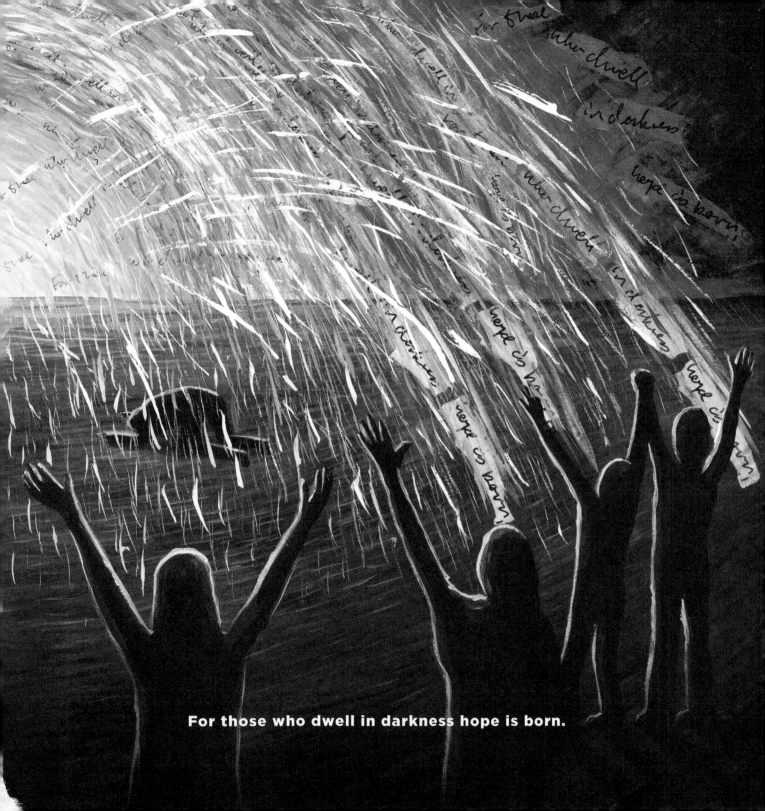

For those who dwell in darkness hope is born.

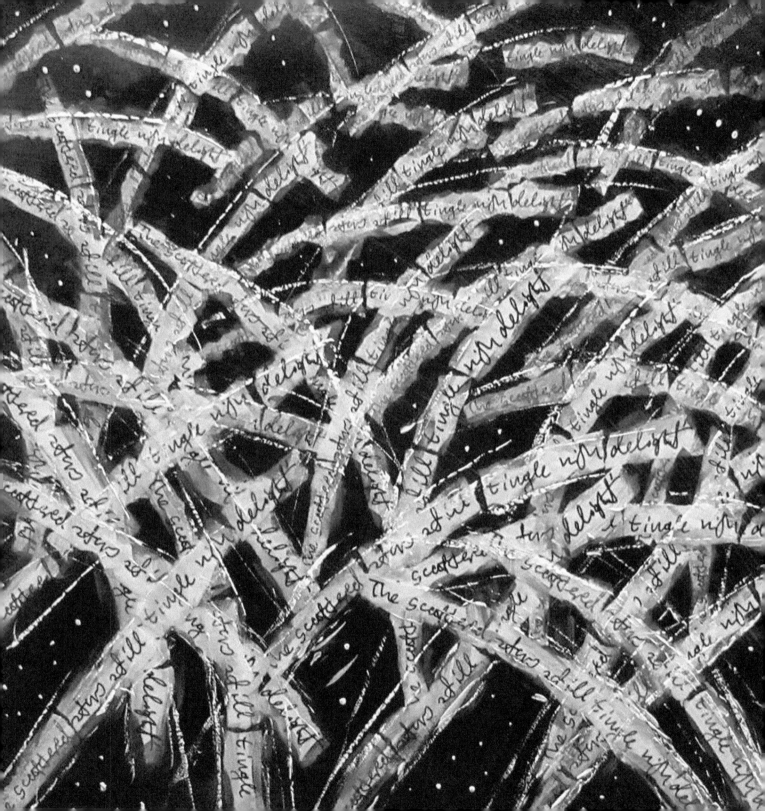

The scattered stars still tingle with delight.

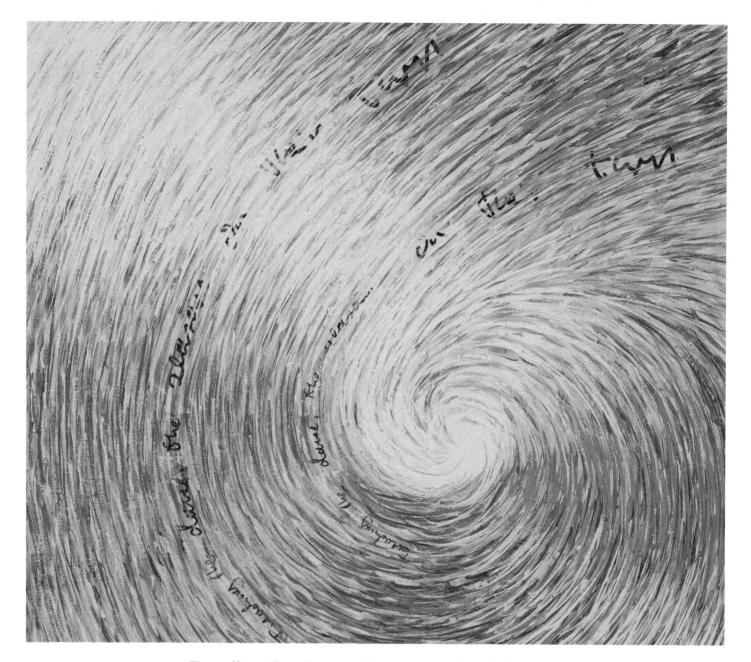

**Treading the dance, the seasons in their turn**

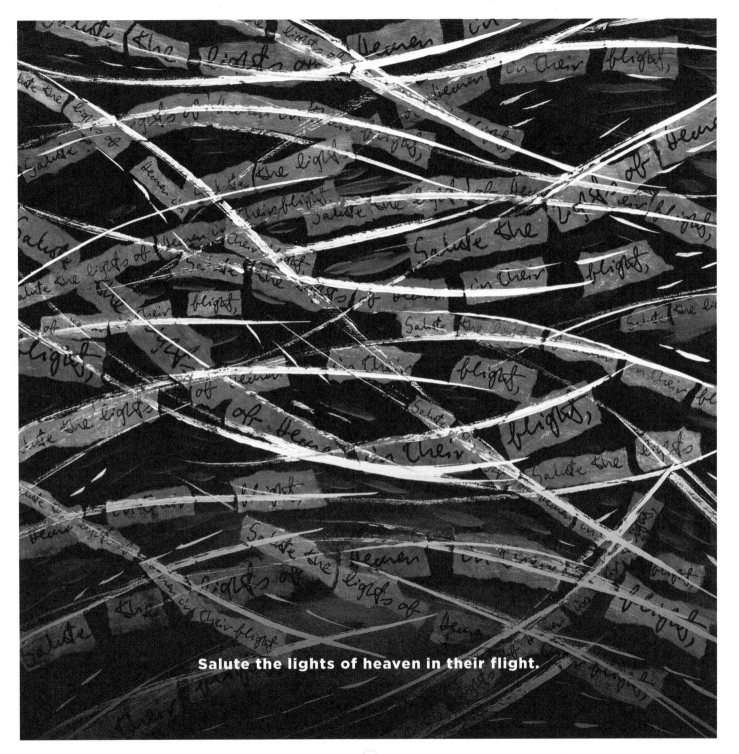

Salute the lights of heaven in their flight.

In our dark hearts Your praises shine and burn;
Lights in the night.

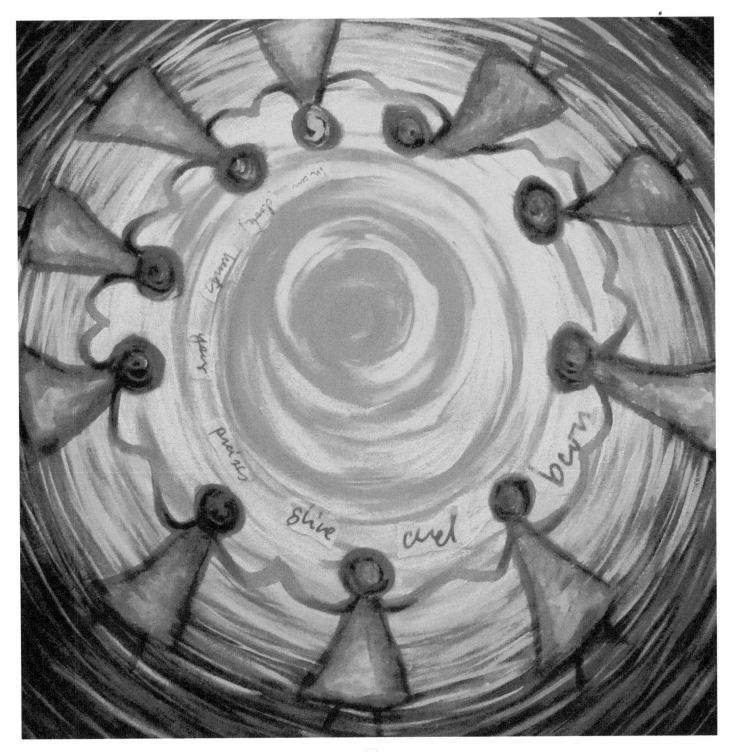

# DAY 5

And God said, Let the waters bring forth abundantly the moving creature that hath life, and fowl that may fly above the earth in the open firmament of heaven. And God created great whales, and every living creature that moveth, which the waters brought forth abundantly, after their kind, and every winged fowl after his kind: and God saw that it was good. And God blessed them, saying, Be fruitful, and multiply, and fill the waters in the seas, and let fowl multiply in the earth. And the evening and the morning were the fifth day.

**GENESIS 1:20-23**

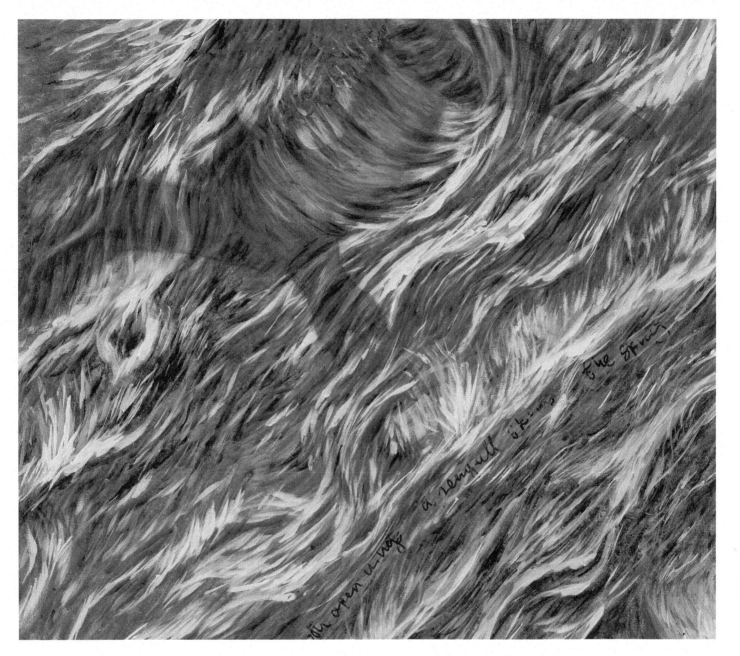

With open wings a seagull skims the spray,

Sounding the depth below, a great whale sings,

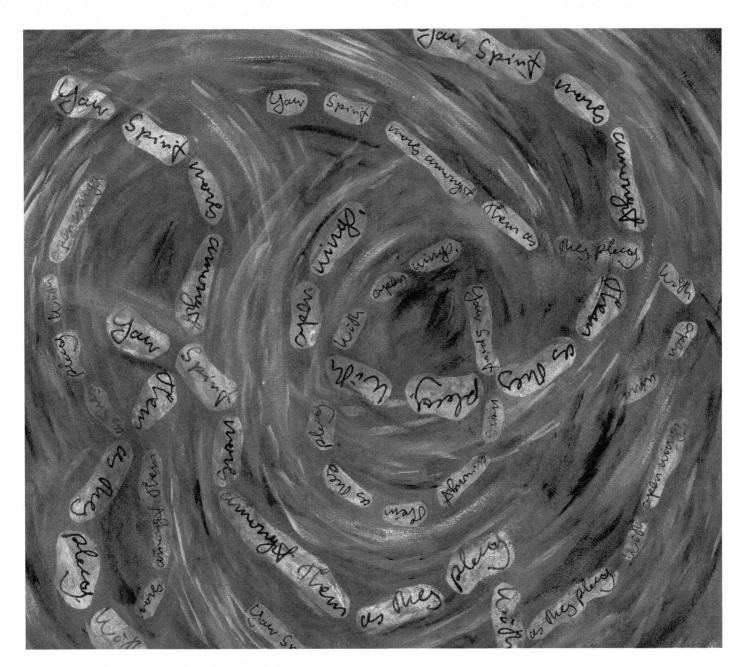

Your Spirit moves amongst them as they play
With open wings.

Now open me to all Your Spirit brings,

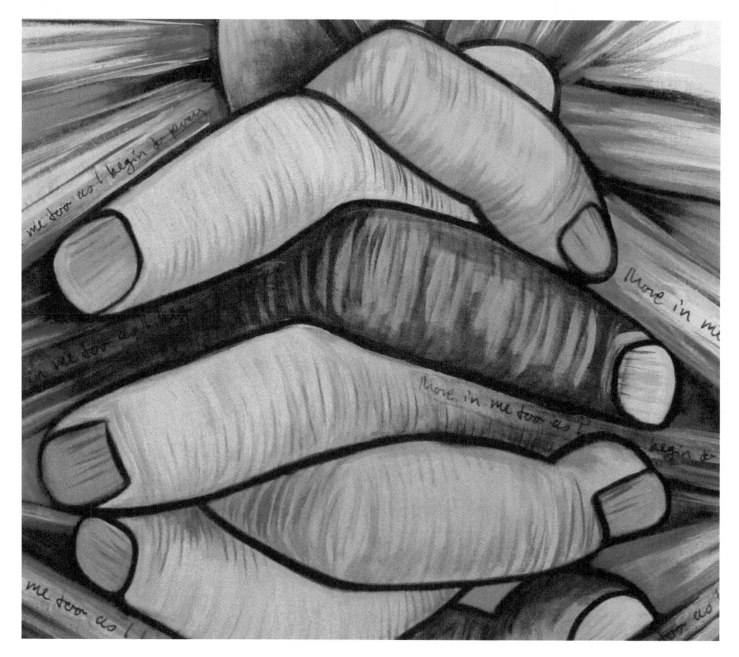

**Move in me too as I begin to pray,**

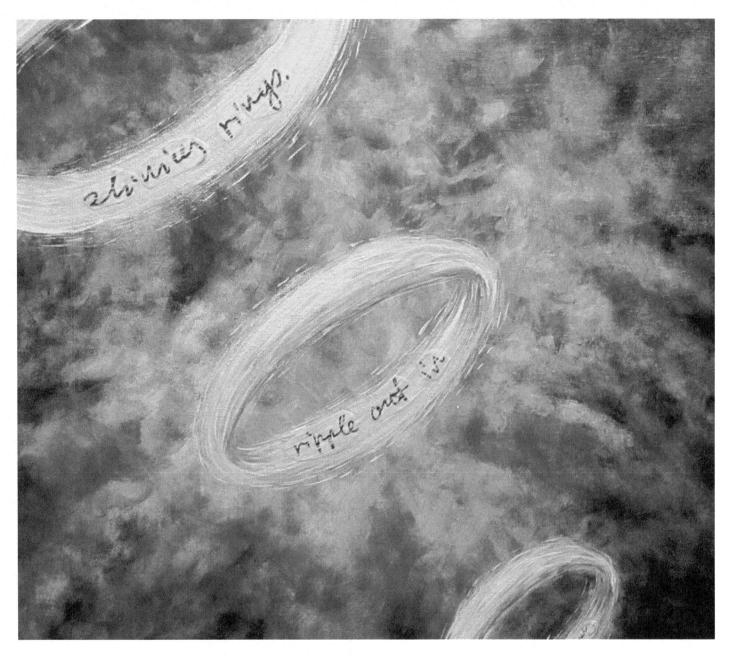

That love may ripple out in shining rings.

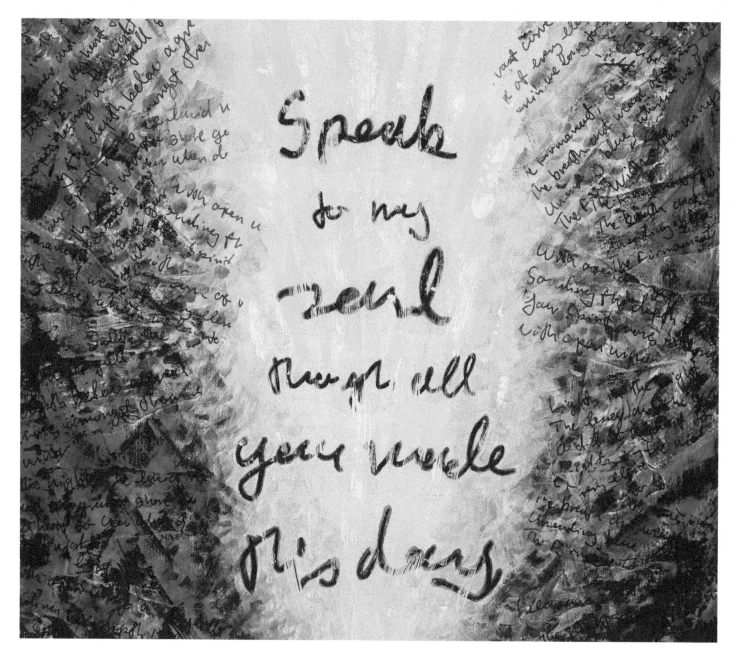

**Speak to my soul through all You made this day,**

Through all that swims and flies and swoops and swings,

And let Your Spirit lift the words I say
With open wings.

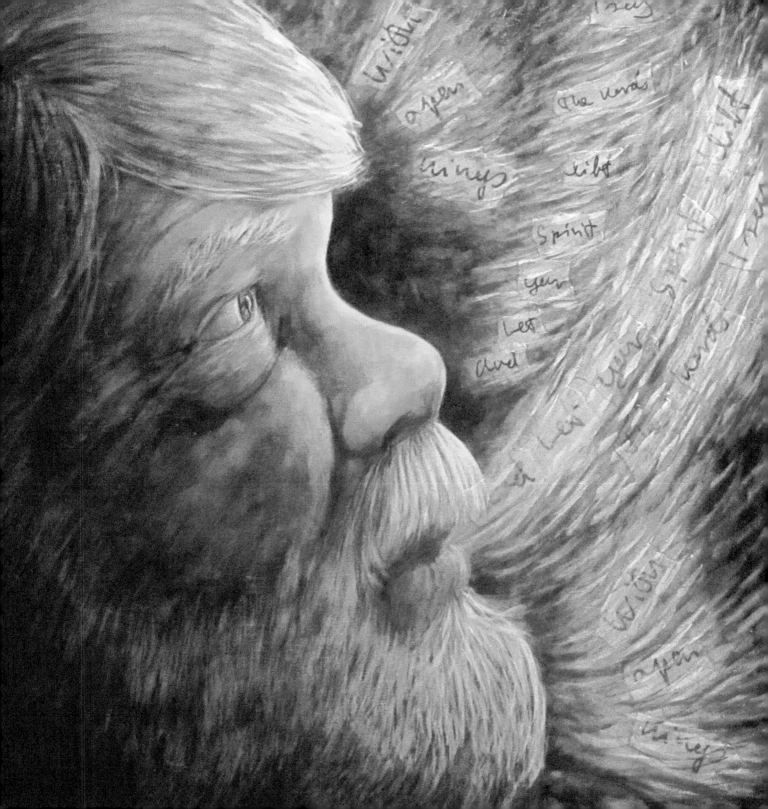

# DAY 6

So God created man in his own image, in the image of God created he him;
male and female created he them. And God blessed them, and God said
unto them, Be fruitful, and multiply, and replenish the earth, and subdue
it: and have dominion over the fish of the sea, and over the fowl of the
air, and over every living thing that moveth upon the earth. And God said,
Behold, I have given you every herb bearing seed, which is upon the face
of all the earth, and every tree, in the which is the fruit of a tree yielding
seed; to you it shall be for meat. And to every beast of the earth, and to
every fowl of the air, and to every thing that creepeth upon the earth,
wherein there is life, I have given every green herb for meat: and it was so.
And God saw every thing that he had made, and, behold, it was very good.
And the evening and the morning were the sixth day.

**GENESIS 1:27–31**

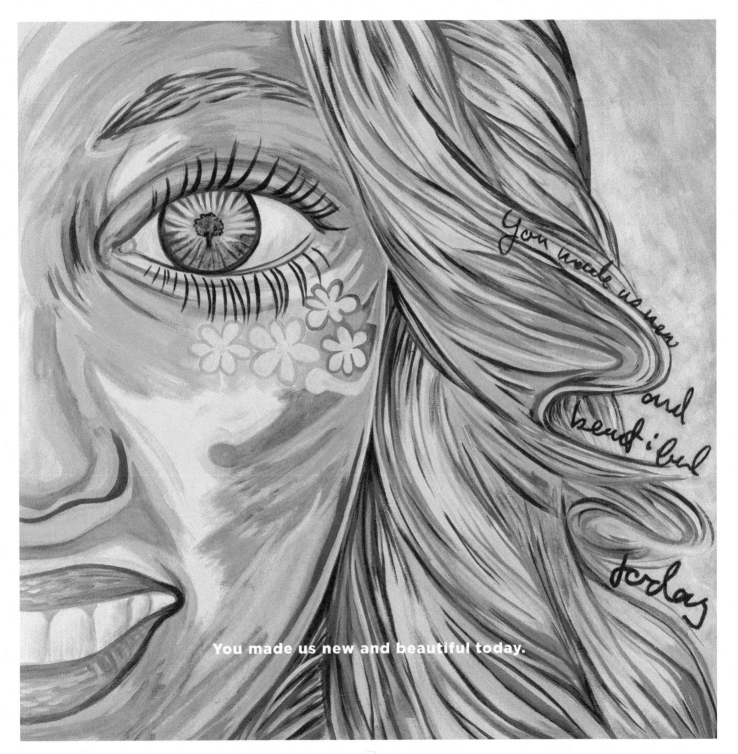

You made us new and beautiful today.

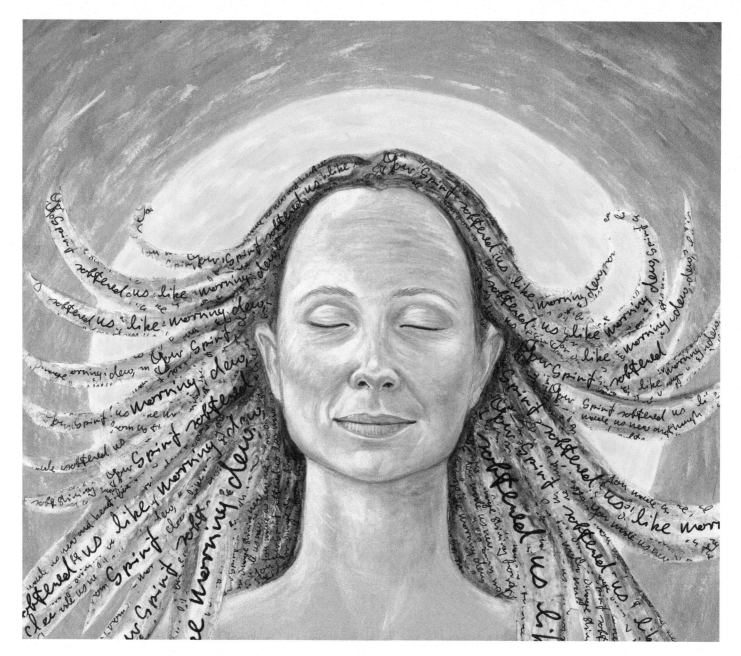

**Your Spirit softened us like morning dew,**

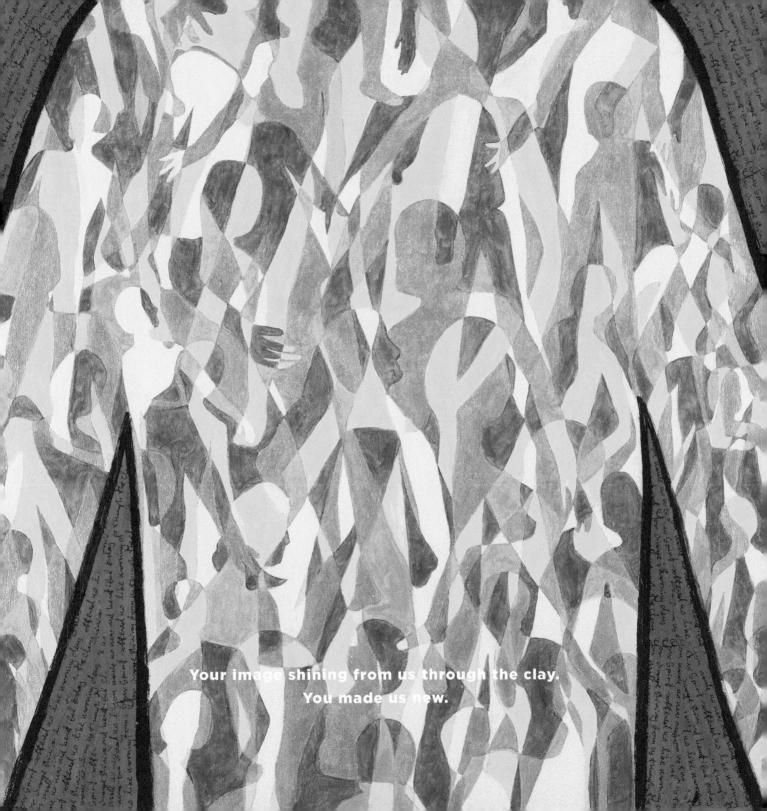

Your image shining from us through the clay.
You made us new.

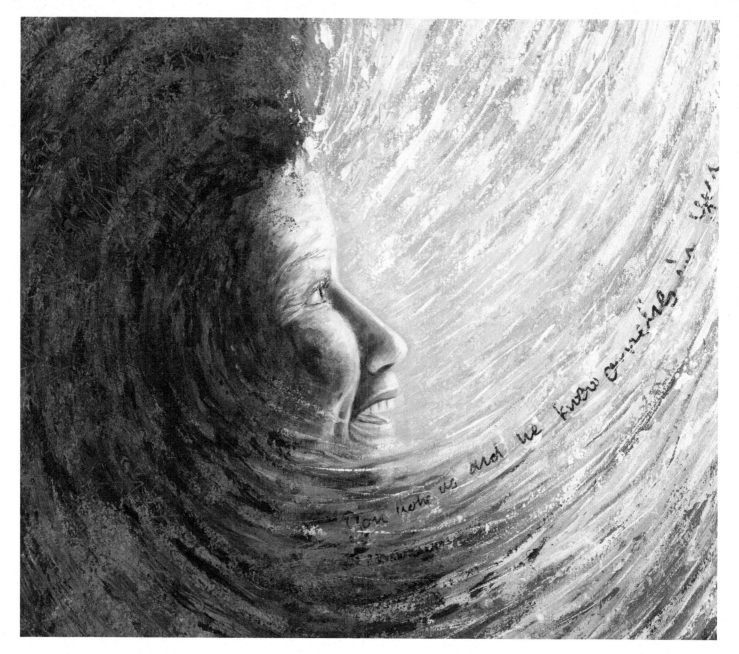

You woke us and we knew ourselves in You

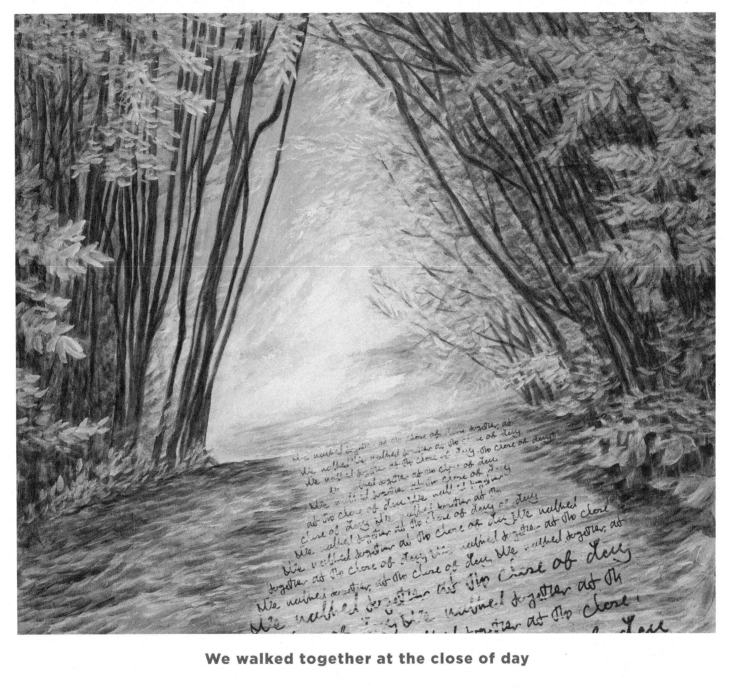

**We walked together at the close of day**

You trusted us and called us to be true.

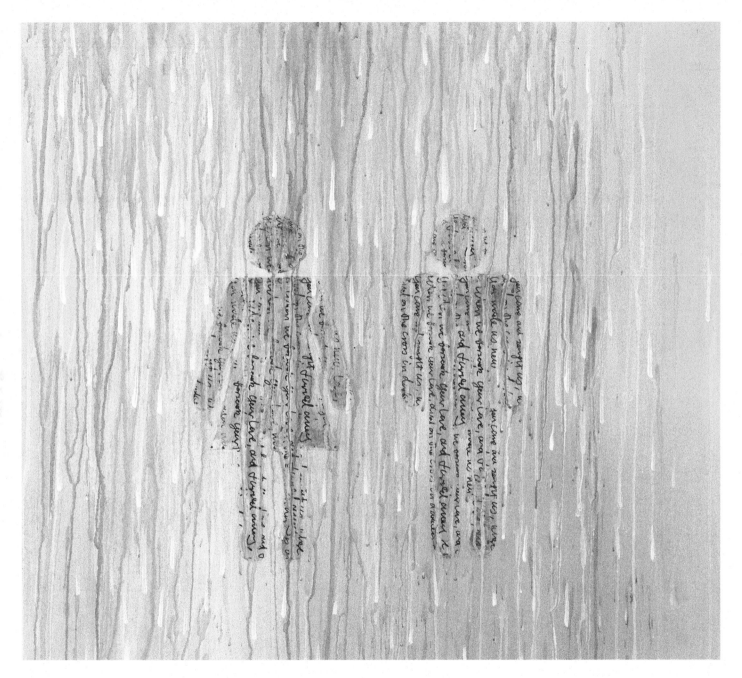

And when we forsook Your love and turned away,

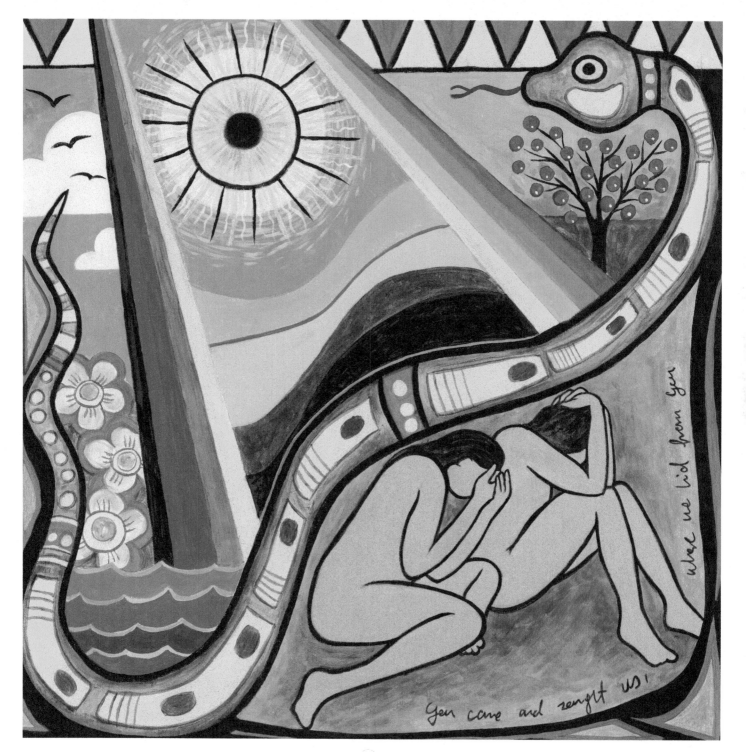

You came and sought us where we hid from You,

And on the cross, in darkness, on this day
You made us new.

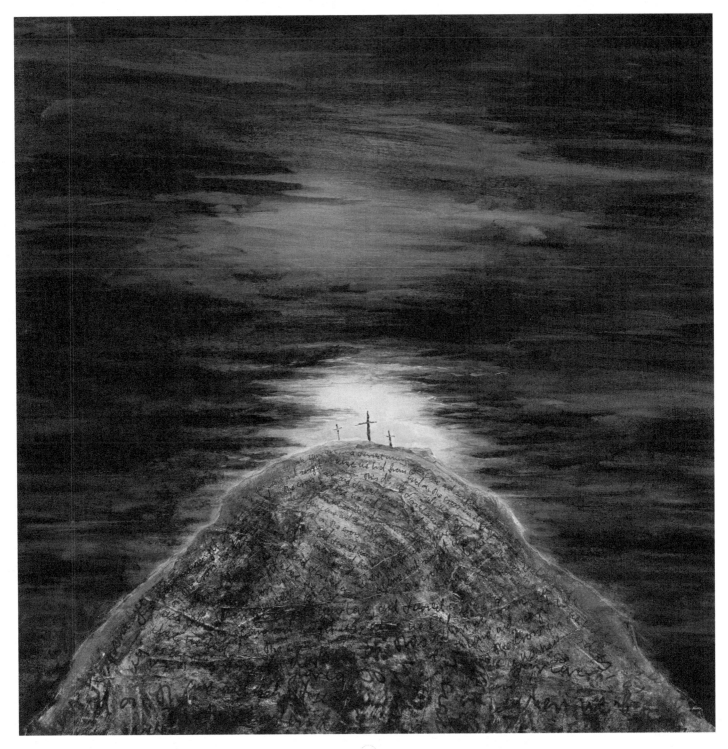

# DAY 7

Thus the heavens and the earth were finished, and all the host of them. And on the seventh day God ended his work which he had made; and he rested on the seventh day from all his work which he had made. And God blessed the seventh day, and sanctified it: because that in it he had rested from all his work which God created and made.

**GENESIS 2:1-3**

Blessing and rest, delight in everything,

**Sustained by Your strong love and richly blest.**

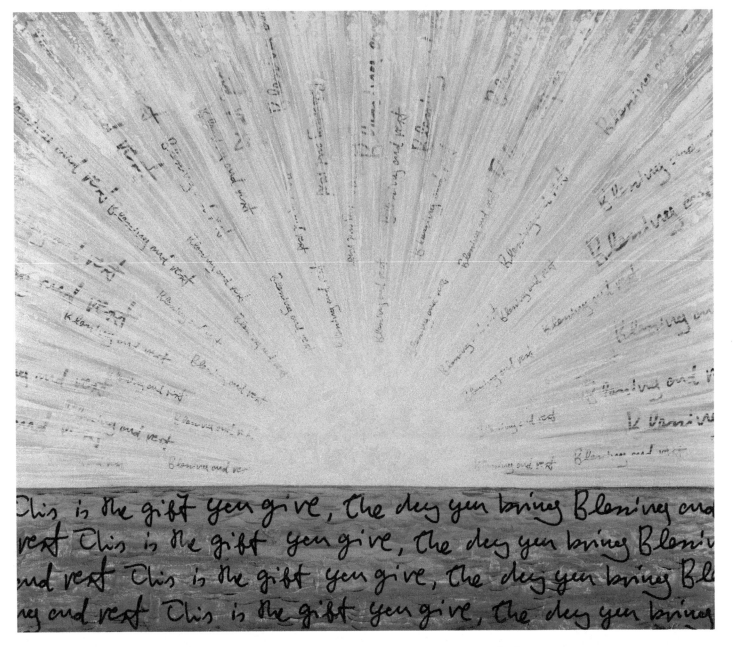

This is the gift You give, the day You bring;
Blessing and rest.

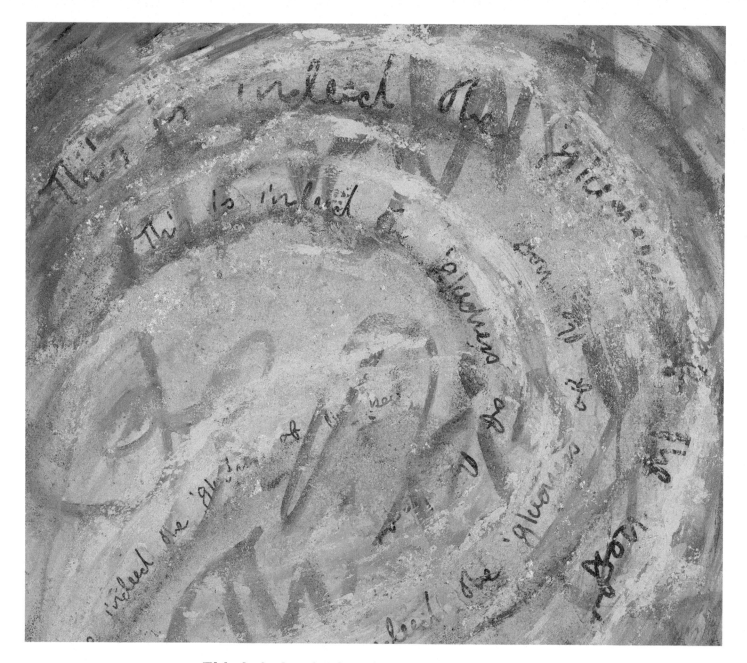

This is indeed "the gladness of the best,"

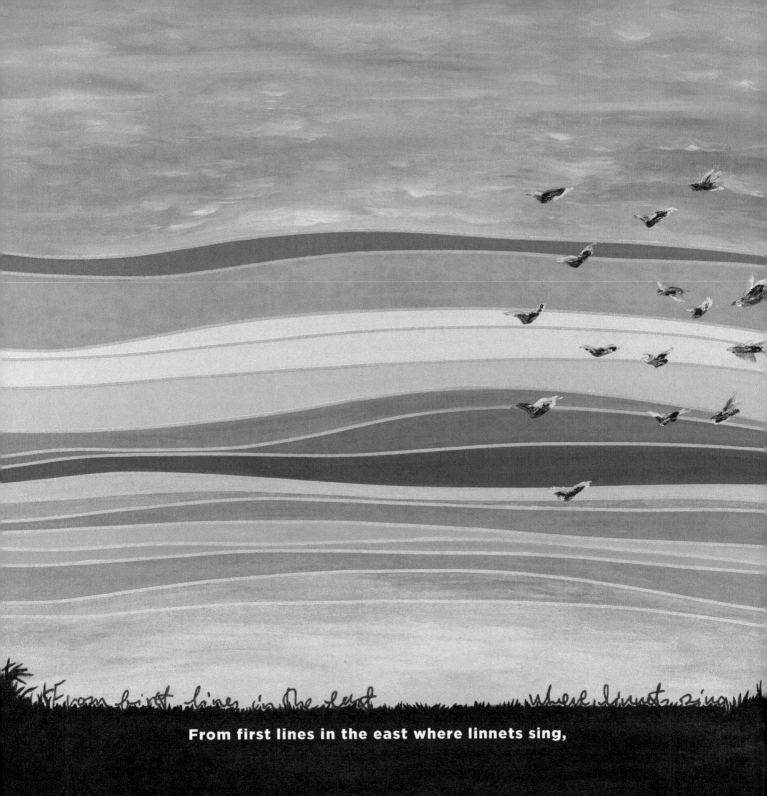

From first lines in the east where linnets sing,

To where the last light lingers in the west

To where the last light lingers in the west.

You lift the cares to which I used to cling,

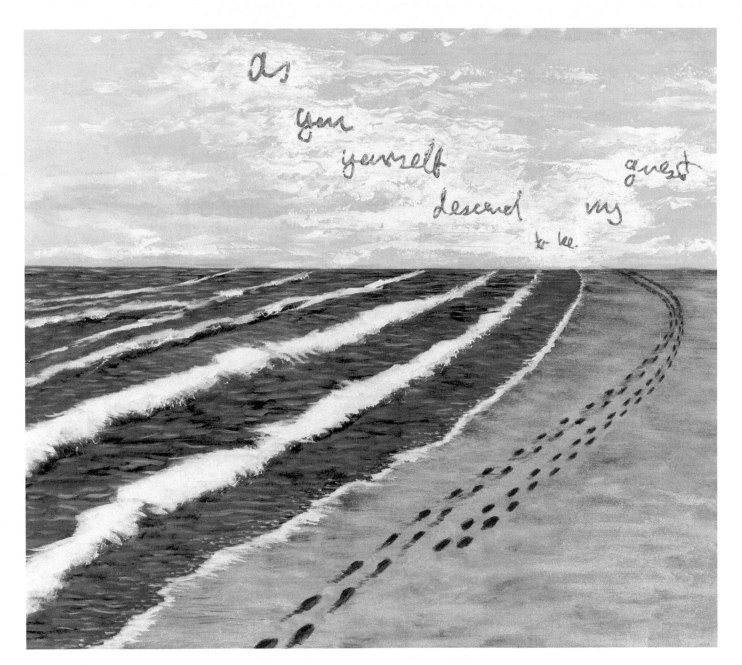

**As You Yourself descend to be my guest**

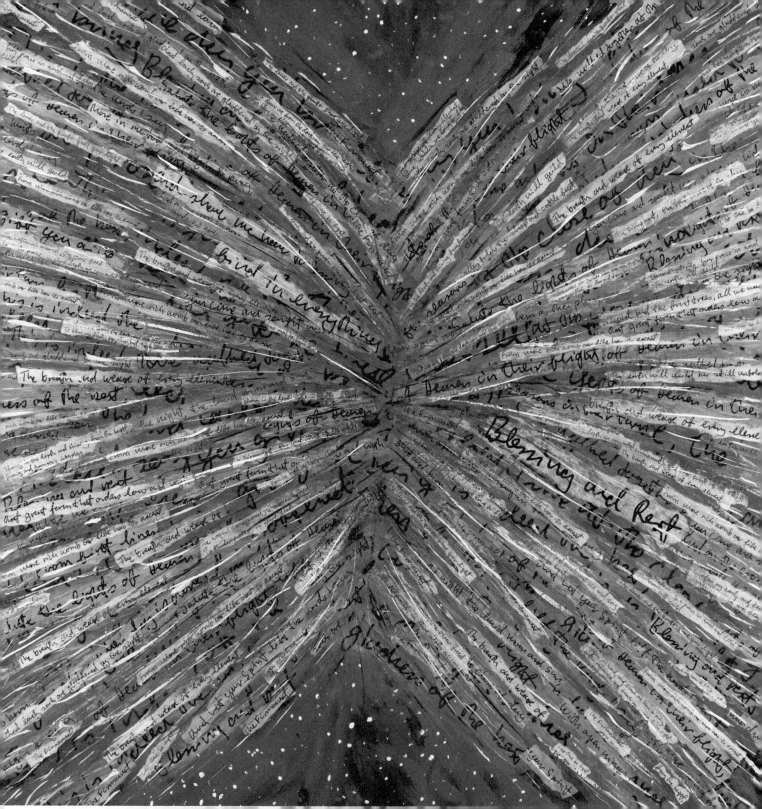

And show me how to find in everything
Blessing and rest.

# DAY 1

Let there be light as I begin this day
To draw me from the darkness and the night,
To bless my flesh, to clear and show my way.
Let there be light.

Strong in the depth and shining from the height,
Evening and morning's interplay,
Blessing and enabling my sight.

Lighten my soul and teach me how to pray,
Lighten my mind and teach me wrong from right,
In all I do and think and see and say;
Let there be light.

# DAY 2

The firmament, the vast curve of the sky
The breath and weave of every element
Unending blue, wherein we long to fly;
The firmament.

Your love has pitched the heavens like a tent
And delved the depth where hidden treasures lie,
From whose rich womb our life has its ascent.

Out of those depths I hear my spirit cry
As height and depth give praise with one assent
To that great form that orders low and high;
The firmament.

# DAY 3

The earth will yield her still-unfolding seed,
And barley sheaves grow golden in the field,
The vineyard and the fruit trees, all we need.
The earth will yield.

A soft wind sends the summer through the weald;
In valley folds the sheep and cattle feed.
The shoreline shines, Your wonders are revealed.

The waters are unbound, the ocean freed
To thunder praise, in whose depths are concealed
Your mysteries. Your praise in word and deed.
The earth will yield.

# DAY 4

Lights in the night, the lucid moon and sun,
The lesser and the greater share Your light
And lift my heart to You when day is done.
Lights in the night.

And lonely souls are gladdened by the sight,
For those who dwell in darkness hope is born.
The scattered stars still tingle with delight.

Treading the dance, the seasons in their turn
Salute the lights of heaven in their flight.
In our dark hearts Your praises shine and burn;
Lights in the night.

# DAY 5

With open wings a seagull skims the spray,
Sounding the depth below, a great whale sings,
Your Spirit moves amongst them as they play
With open wings.

Now open me to all Your Spirit brings,
Move in me too as I begin to pray,
That love may ripple out in shining rings.

Speak to my soul through all You made this day,
Through all that swims and flies and swoops and swings,
And let Your Spirit lift the words I say
With open wings.

# DAY 6

You made us new and beautiful today.
Your Spirit softened us like morning dew,
Your image shining from us through the clay.
You made us new.

You woke us and we knew ourselves in You
We walked together at the close of day
You trusted us and called us to be true.

When we forsook Your love and turned away,
You came and sought us where we hid from You,
And on the cross, in darkness, on this day
You made us new.

# DAY 7

Blessing and rest, delight in everything,
Sustained by Your strong love and richly blest.
This is the the gift You give, the day You bring;
Blessing and rest.

This is indeed "the gladness of the best,"
From first lines in the east where linnets sing,
To where the last light lingers in the west.

You lift the cares to which I used to cling,
As You Yourself descend to be my guest
And show me how to find in everything
Blessing and rest.

**by Malcolm Guite**
**www.malcolmguite.com**

CPSIA information can be obtained
at www.ICGtesting.com
Printed in the USA
BVOW05s1131220118
505527BV00010B/31/P